LET'S EXPLORE THE AUSTRALIAN OUTBACK

SPEEDY
PUBLISHING

Speedy Publishing LLC
40 E. Main St. #1156
Newark, DE 19711
www.speedypublishing.com

The Outback is the vast, remote, arid interior of Australia. The Outback covers most of Australia.

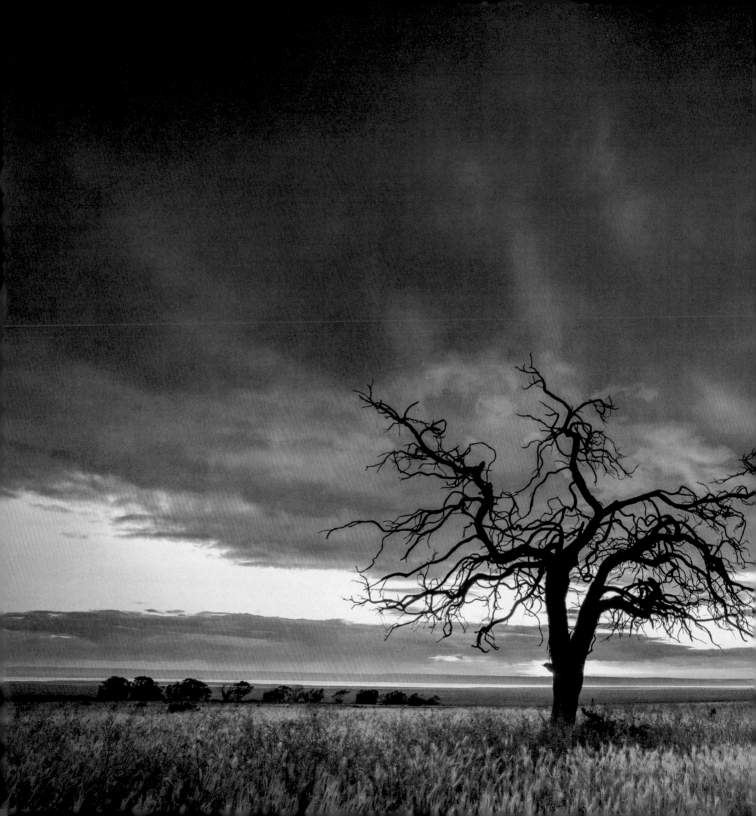

FLINDERS RANGES

are the largest mountain range in South Australia. Summers usually have temperatures reaching over 38 °C, while winters have highs around 13 °C-16 °C.

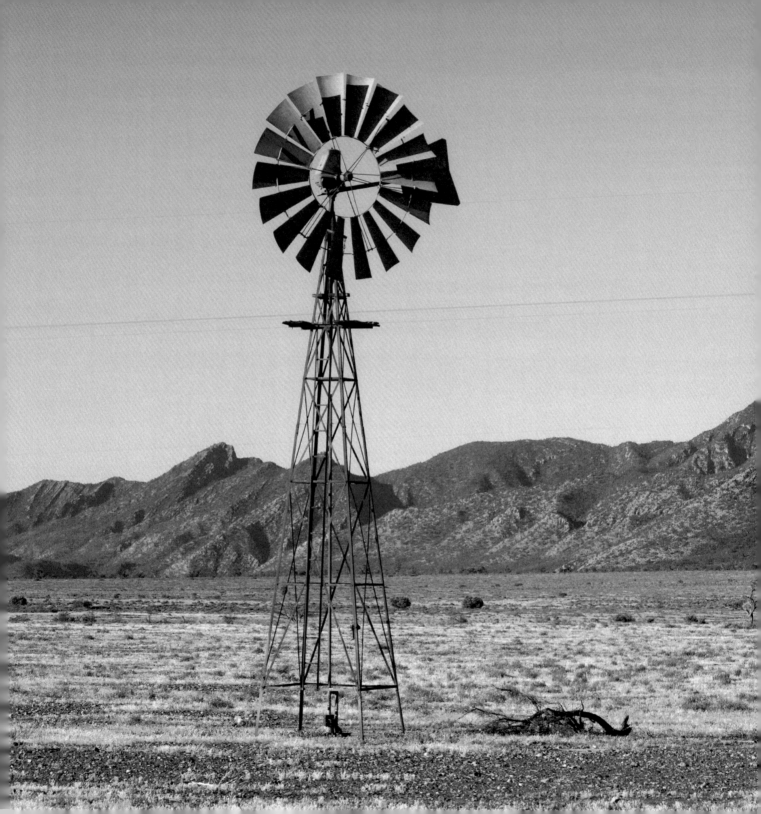

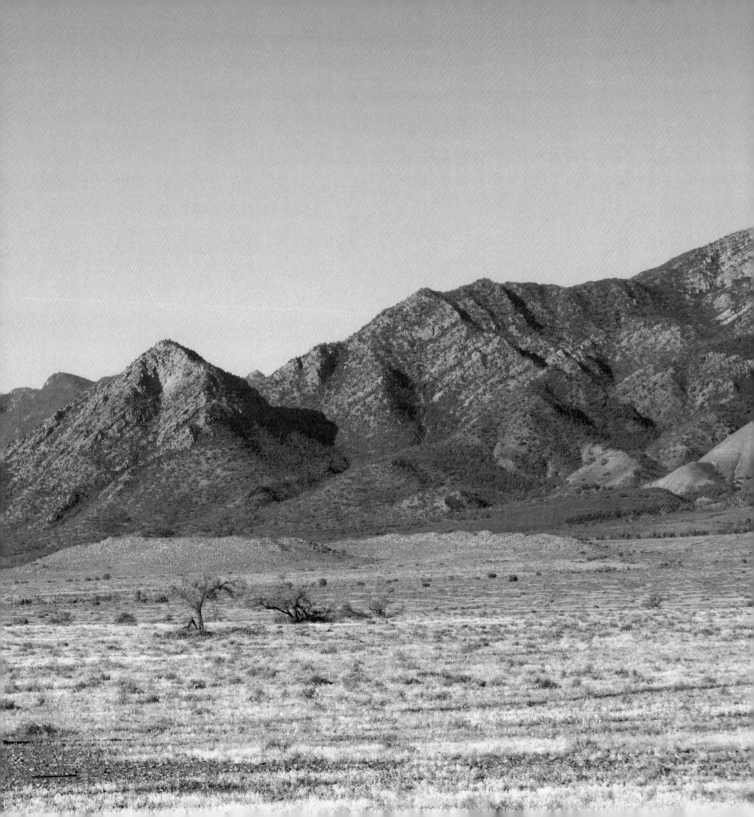

BROKEN HILL, NEW SOUTH WALES

is a city in the far west of New South Wales, surrounded by vast arid plains. Broken Hill has been referred to as 'The Silver City', the 'Oasis of the West', and the 'Capital of the Outback'.

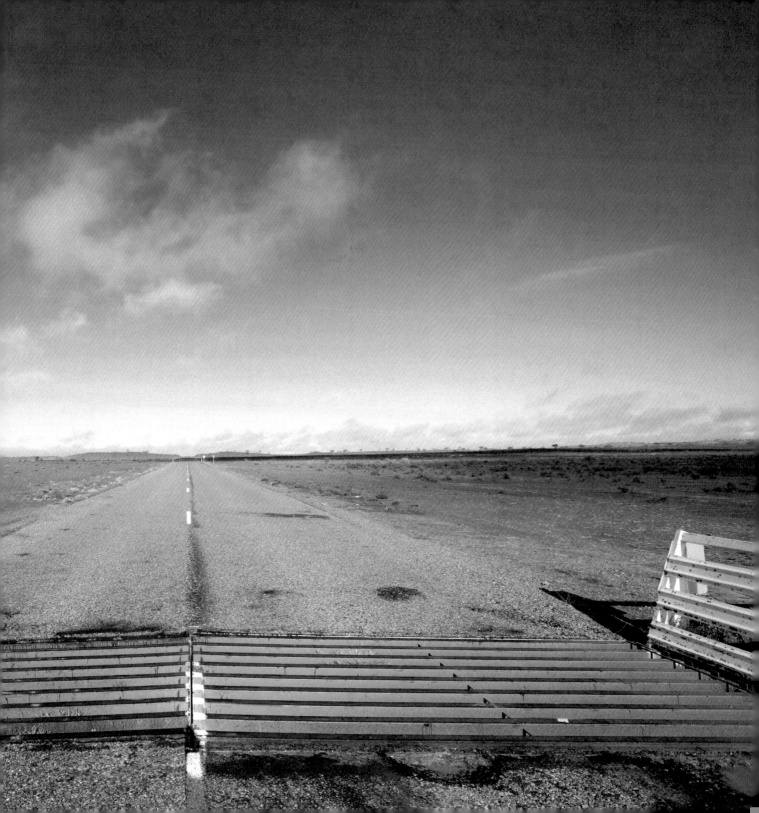

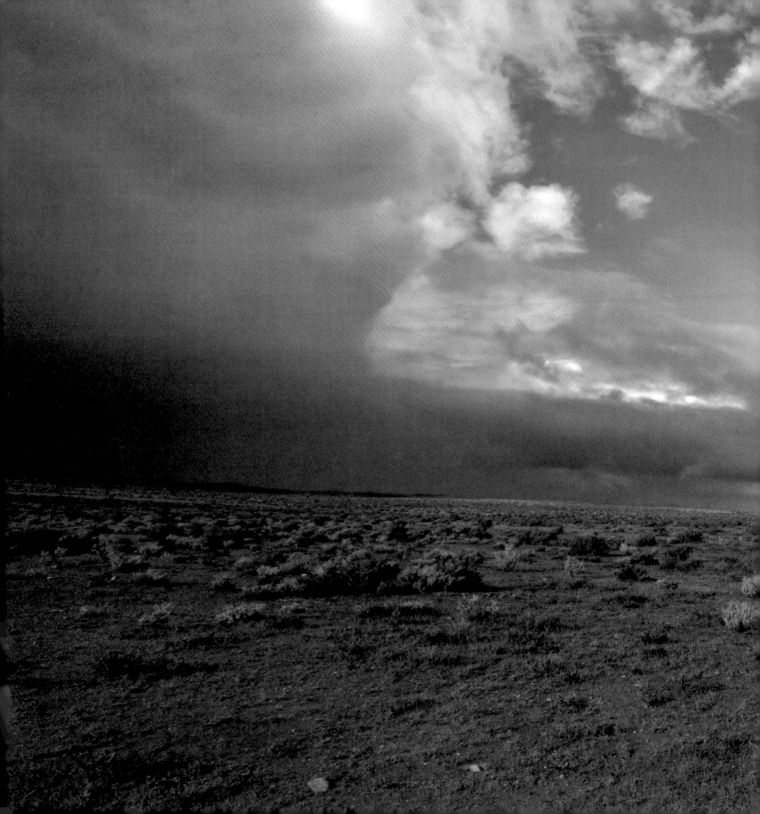

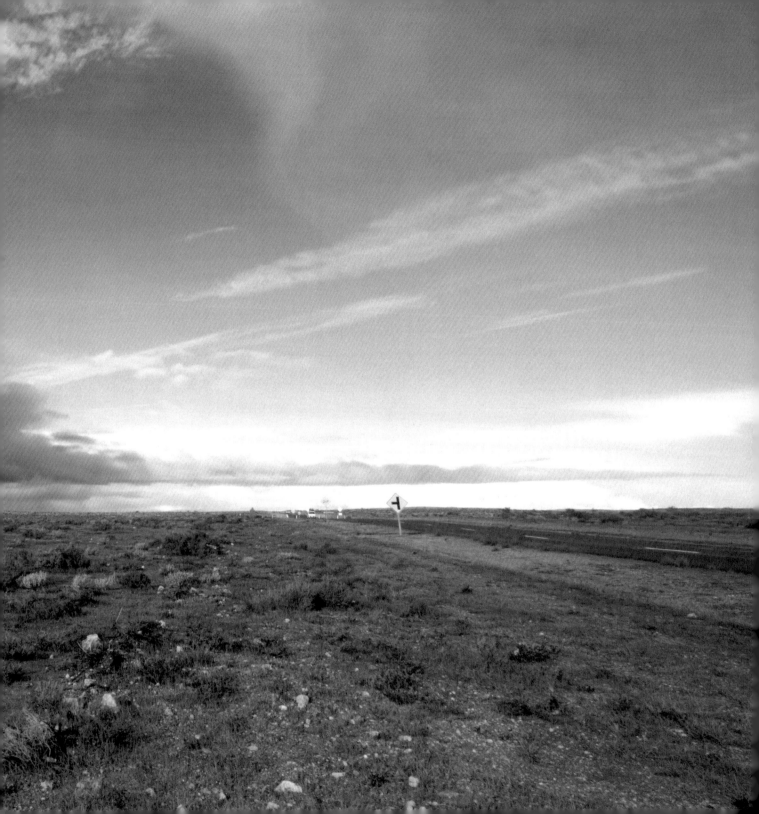

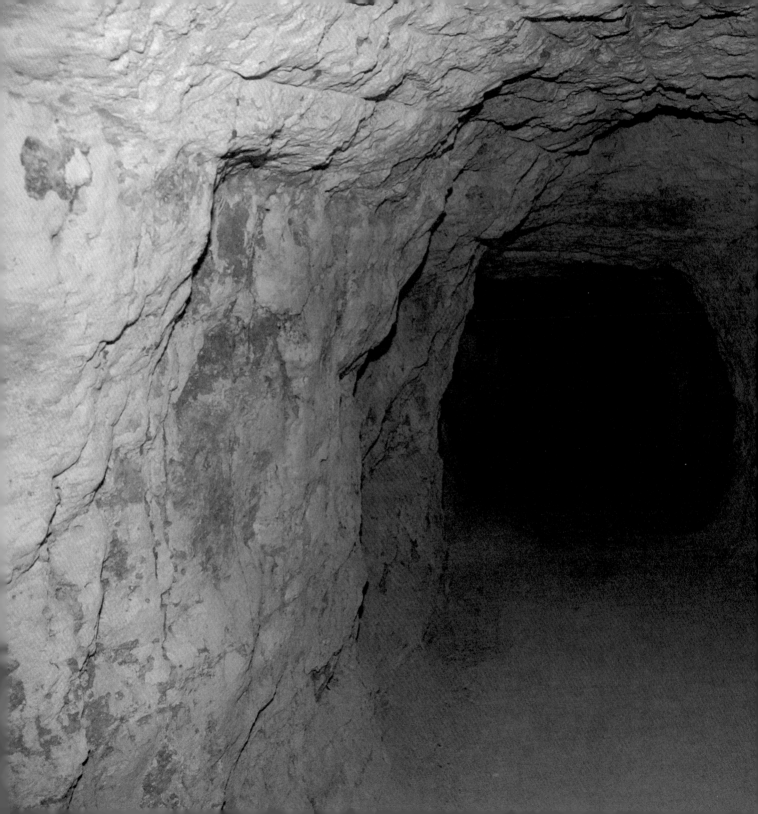

COOBER PEDY

is a town in northern South Australia. Coober Pedy is renowned for its below-ground residences, called "dugouts", which are built in this fashion due to the scorching daytime heat.

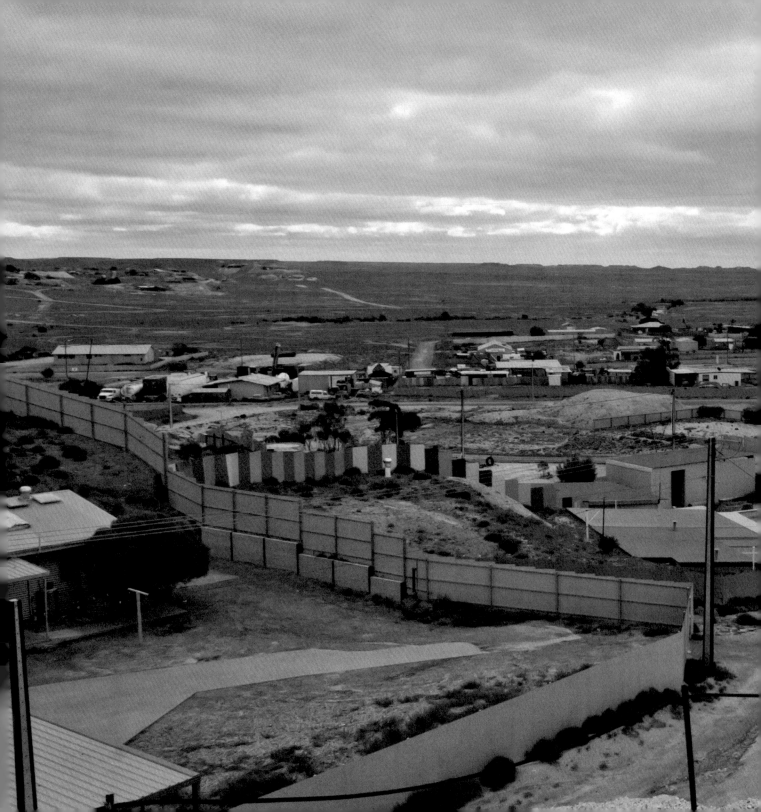

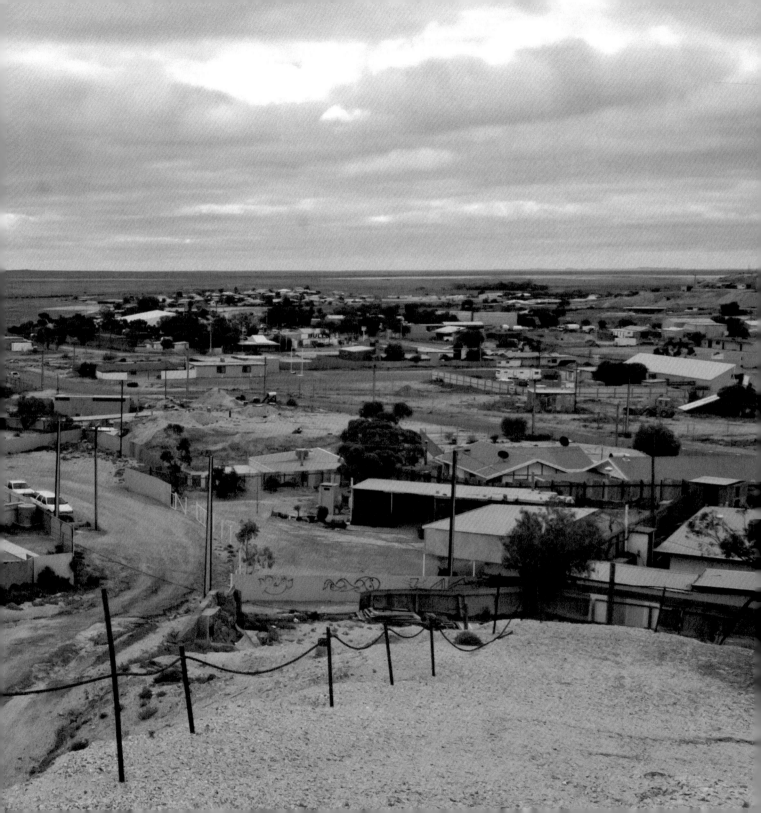

KIMBERLEY

is located in the
northern part of
Western Australia.
The Kimberley was
one of the earliest
settled parts of
Australia. The
Kimberley is one of
the hottest parts of
Australia

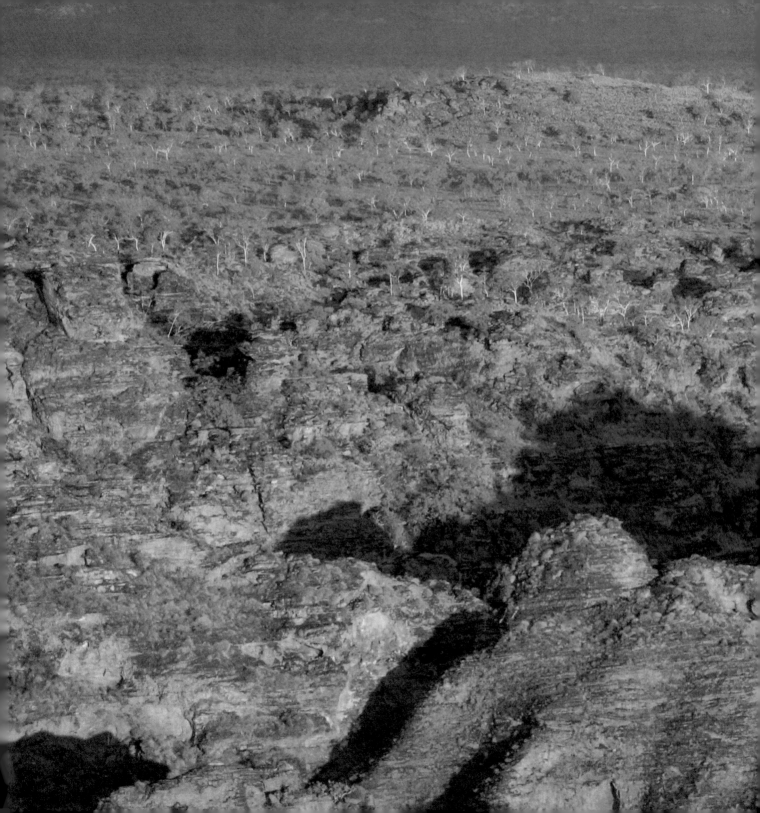

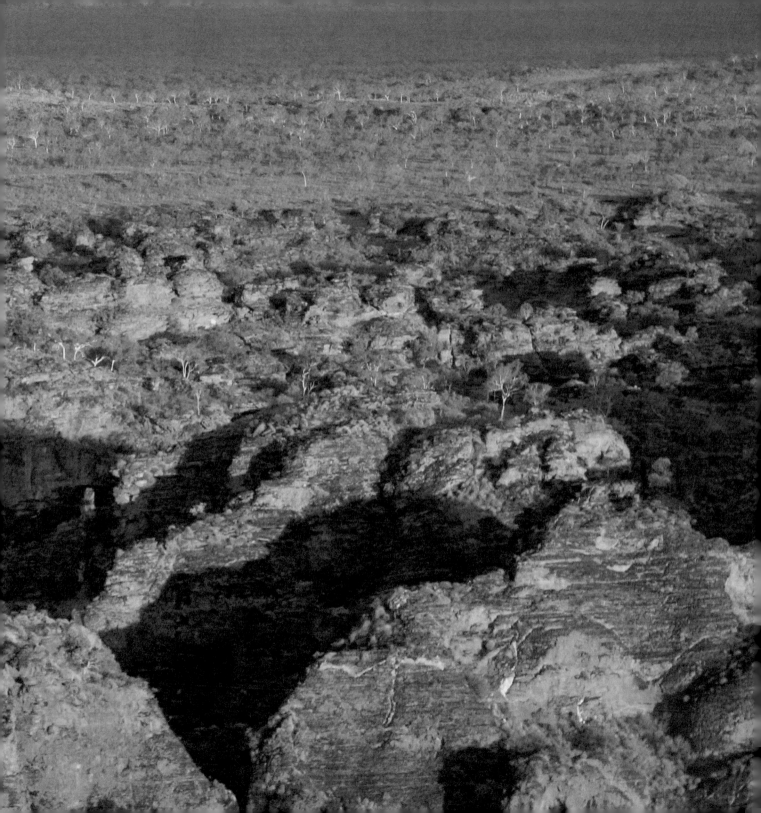

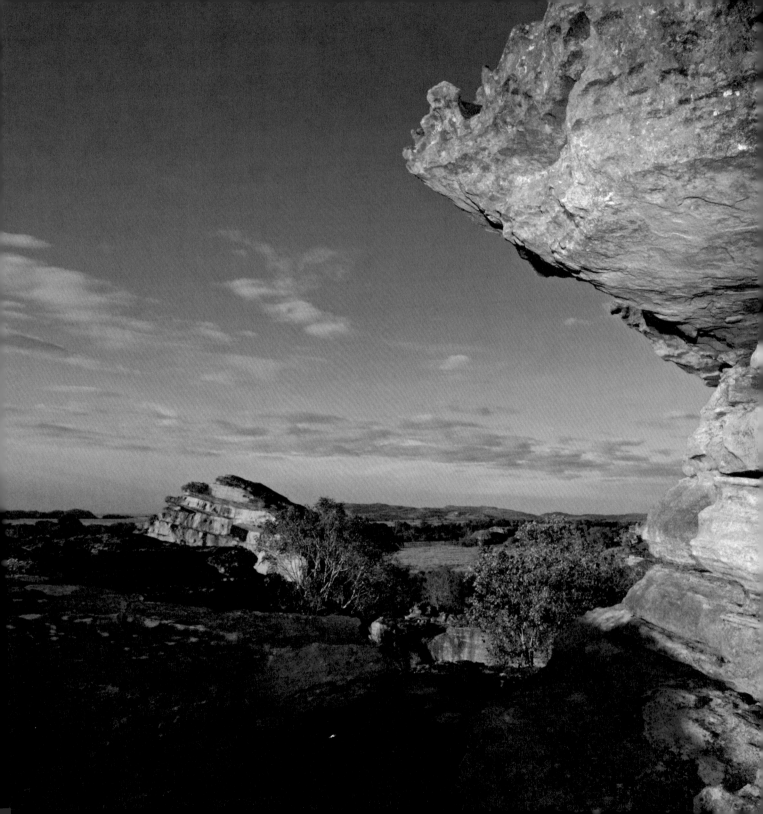

KAKADU NATIONAL PARK

is located in the top part of the Northern Territory. Kakadu National Park is a home to around 280 different types of birds - around a third of all the bird species in Australia.

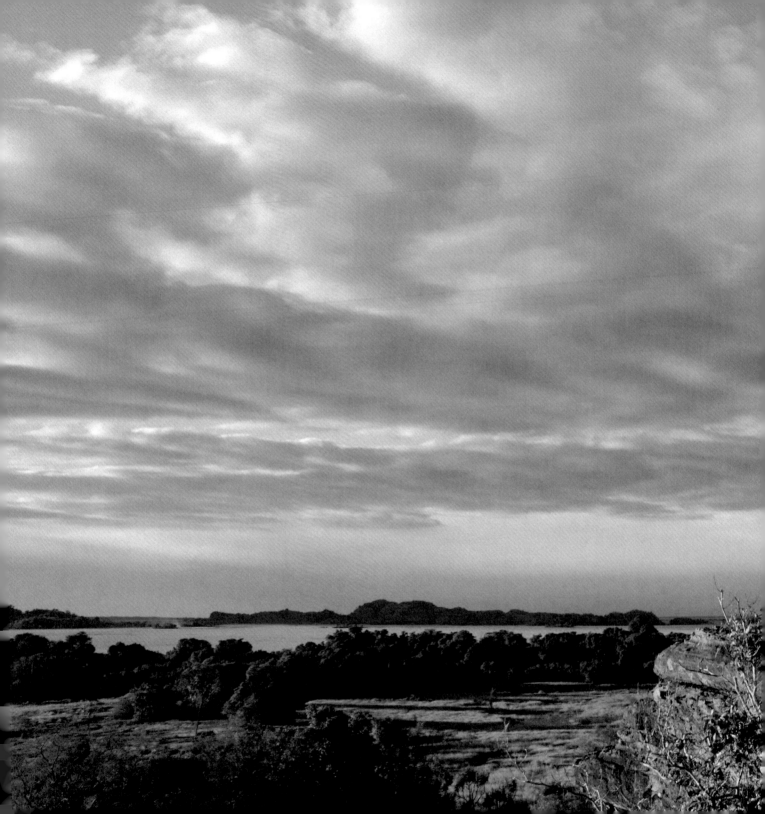

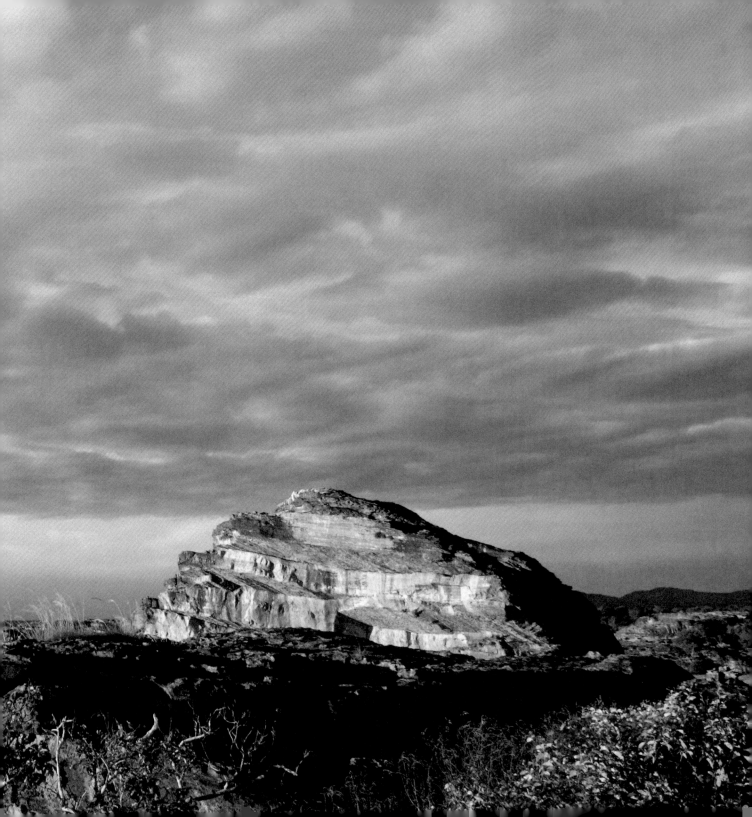

NULLARBOR PLAIN

is famously known as the longest stretch of straight road in the world. The Nullarbor has up to 100,000 wild camels which were abandoned there after their use in building rail roads.

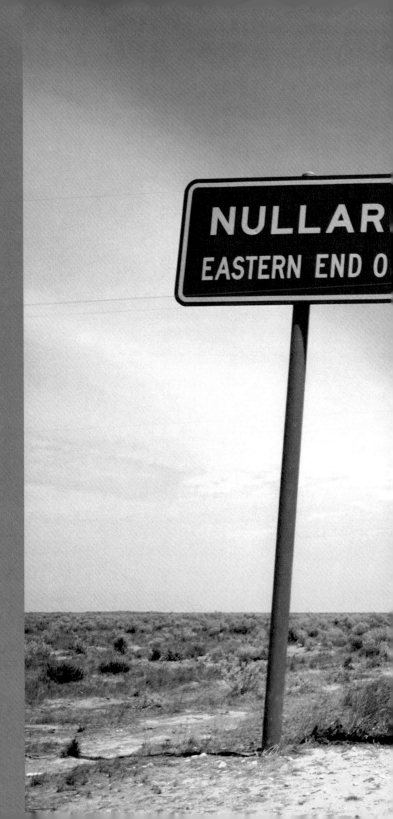

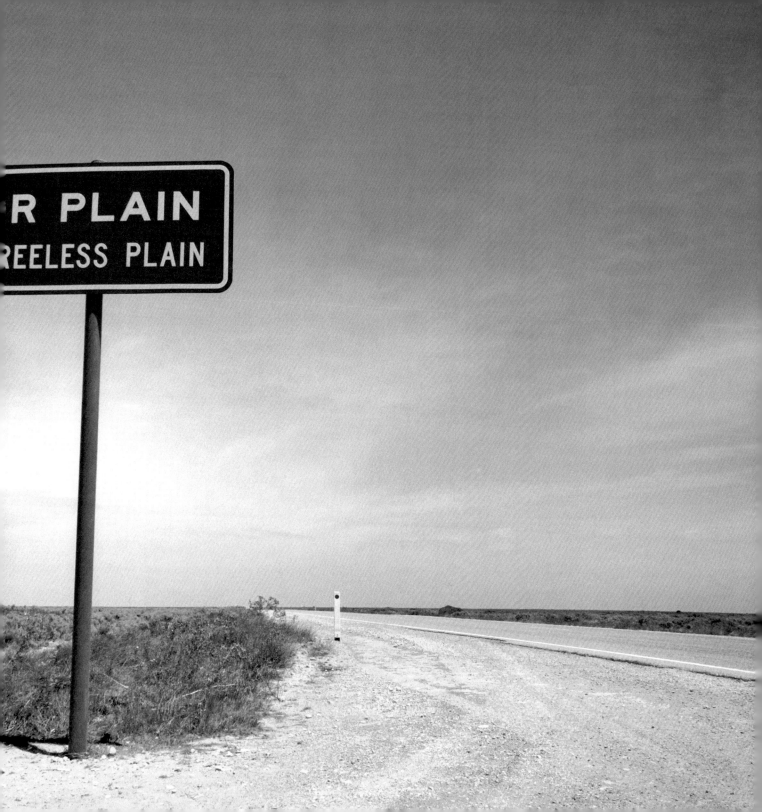

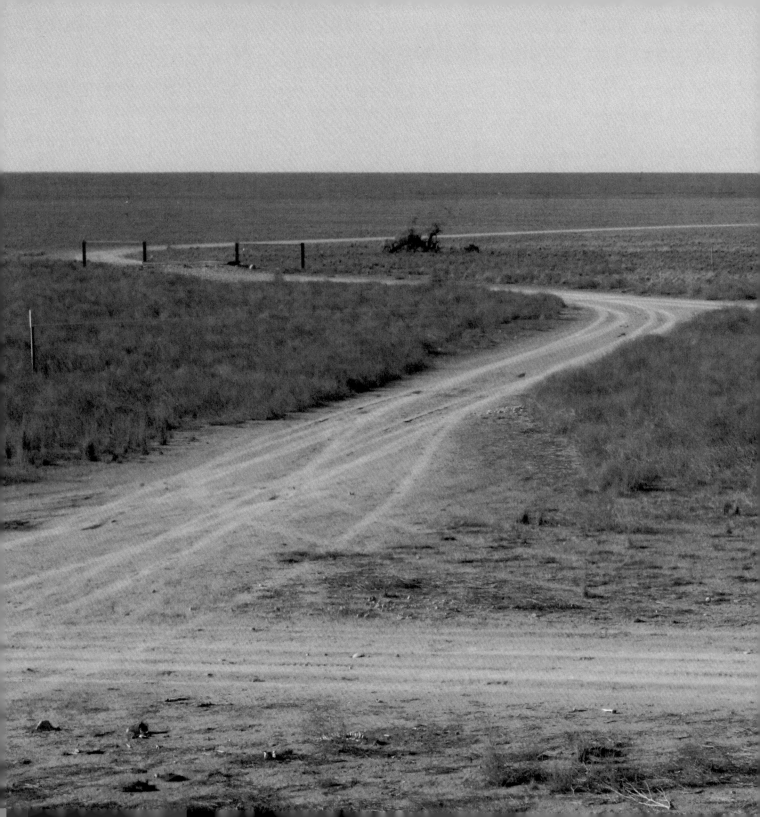

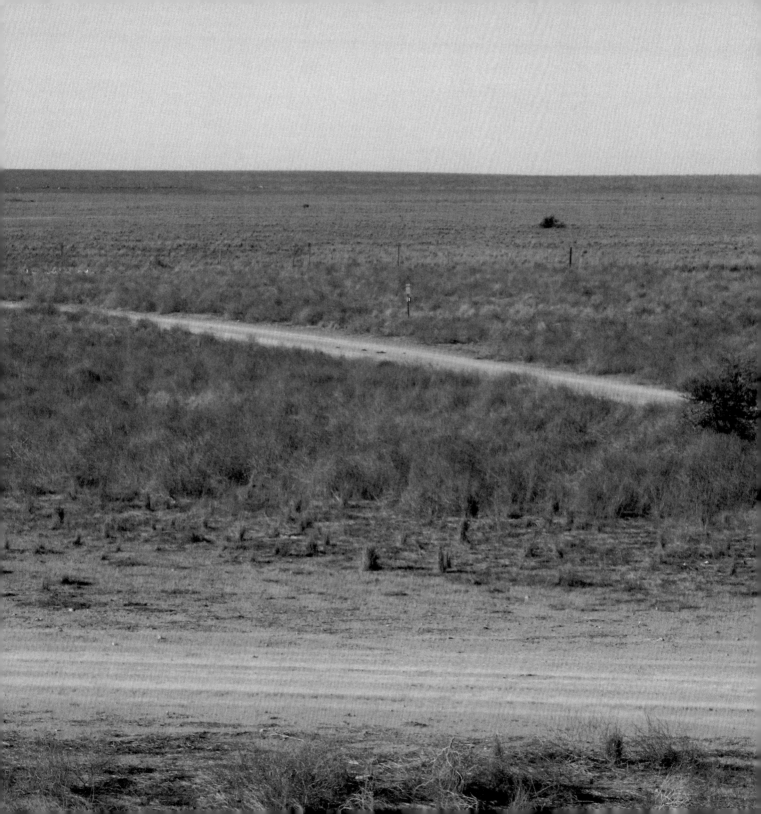

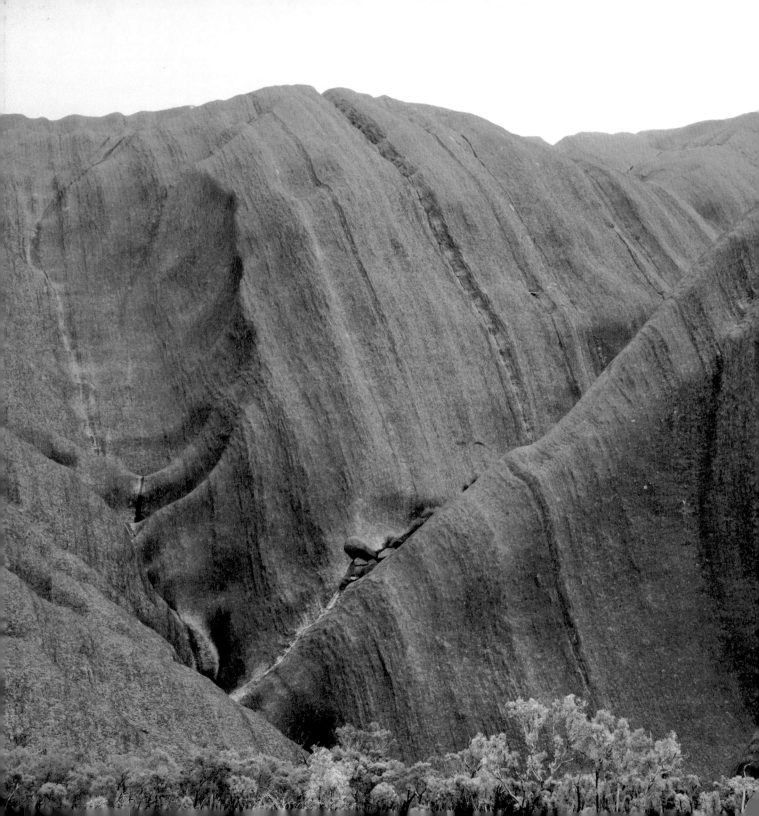

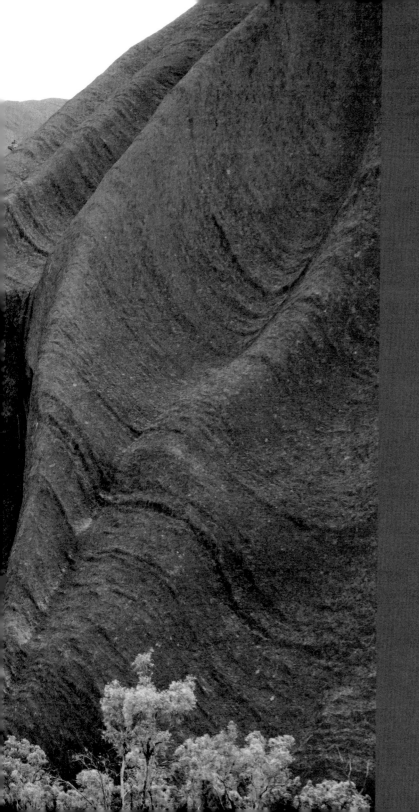

ULURU

is a large sandstone
rock formation in
the southern part
of the Northern
Territory in central
Australia. Uluru is
estimated to be
around 600 million
years old.

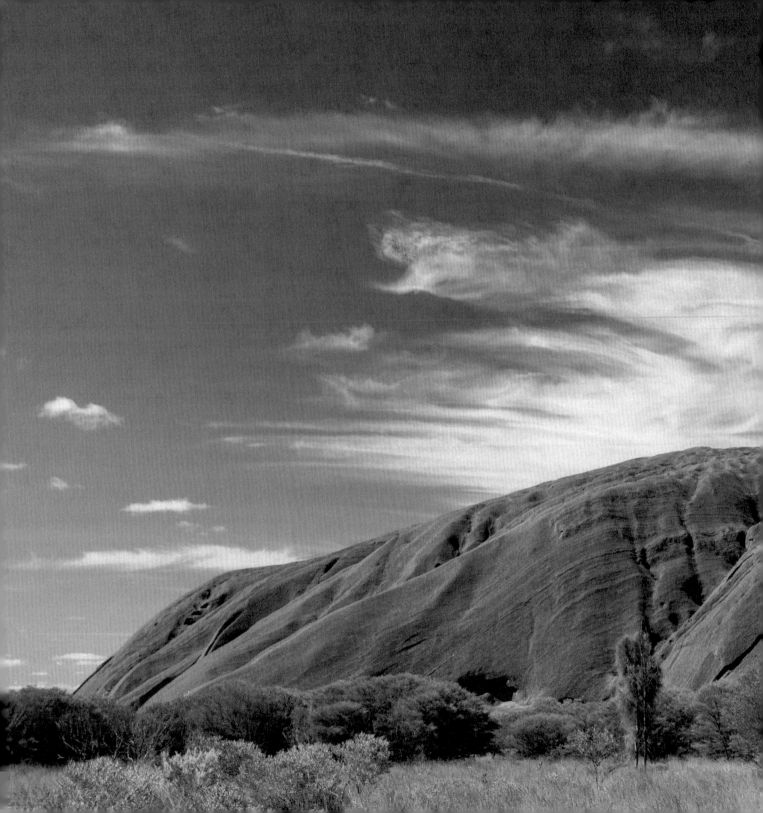

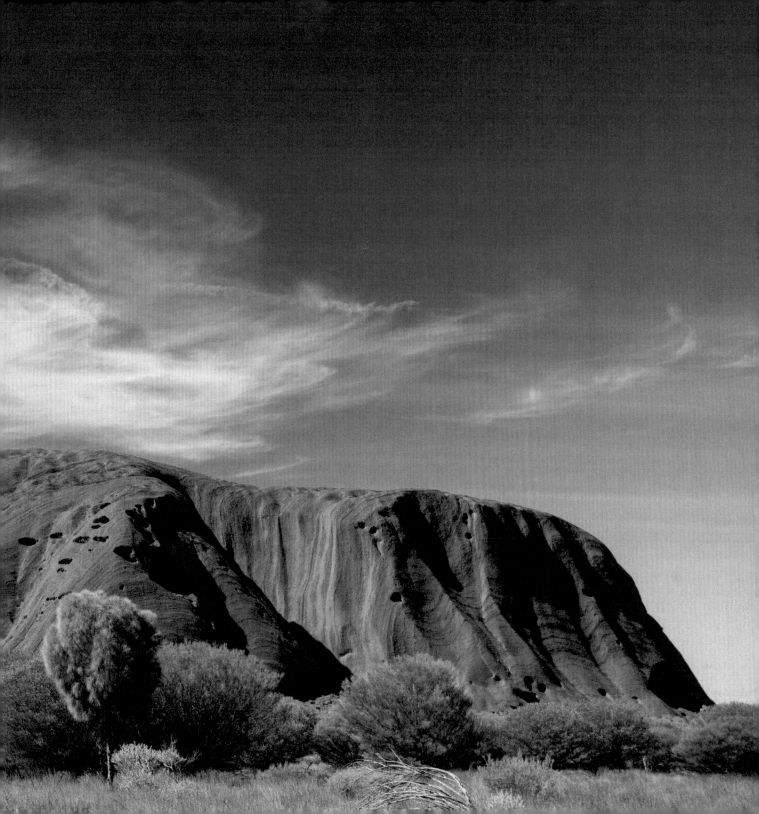

38178506R00020

Made in the USA
San Bernardino, CA
01 September 2016